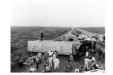

Aernout Mik›Refraction

Exhibition organized by Dan Cameron

on Aernout

Mik>Refraction

With essays by
Dan Cameron
Andrea Inselmann

New Museum of Contemporary Art, New York
Hammer Museum, Los Angeles
Museum of Contemporary Art, Chicago

Aernout Mik>Refraction

New Museum of Contemporary Art, New York
June 23–September 10, 2005

Museum of Contemporary Art, Chicago
June 28–September 25, 2005

Hammer Museum, Los Angeles
Fall 2006

Aernout Mik>Refraction is part of the Three M Project, a series by
the Museum of Contemporary Art, Chicago; the Hammer Museum,
Los Angeles; and the New Museum of Contemporary Art, New York
to commission, organize, and co-present new works of art. Generous
support for the series has been provided by the Peter Norton Family
Foundation and the American Center Foundation.

Aernout Mik>Refraction also received support from the
Mondriaan Foundation, Amsterdam, and The Consulate General of
The Netherlands in New York.

Mondriaan Stichting
(Mondriaan Foundation)

The New Museum of Contemporary Art receives general operating
support from the Carnegie Corporation, the New York State Council
on the Arts, the New York City Department of Cultural Affairs,
JPMorgan Chase, and members of the New Museum.

The catalogue is made possible by the Penny McCall Publication Fund
at the New Museum. Donors to the Penny McCall Publications Fund are
James C. A. and Stephania McClennen, Jennifer McSweeney, Arthur
and Carol Goldberg, Dorothy O. Mills, and the Mills Family Fund.

LCCN: 2005920969
ISBN: 0-915557-89-4

The individual views expressed in the exhibition and publication
are not necessarily those of the Museum.

NEW MUSEUM
New Museum of Contemporary Art
www.newmuseum.org

Production Manager: Melanie Cohn
Designer: Pure+Applied
Printer: SYL Creaciones Graficas Y Publicitarias, S.A.

Aernout Mik
Refraction, 2004
DVD; 3 projected images creating a single 4:1 ratio, panoramic image

Co-Direction: Marjoleine Boonstra
Photography: Benito Strangio
Steady-Cam Operator: Jo Vermaercke
Art Direction: Elsje de Bruijn
Production: Dirk Tolman, Jelier & Schaaf
Production Assistant: Anca Munteanu

Thanks to: Cam-A-Lot, Mark Gastkemper, Petro van Leeuwen
(Ultimate), Laurens Meulenberg, Saga Film (Bucharest), Traffic,
Ynse Ijzenbrandt.

All images courtesy of the artist; carlier | gebauer, Berlin; and
The Project, New York and Los Angeles.

Foreword

We are extremely pleased to present Aernout Mik's **Refraction** (2004), an extraordinary and nuanced installation by a Dutch artist who has had significant recognition in Europe but whose work is just beginning to be seen in the U.S. The ambition of this product and the conceptual, spatial, and emotional complexity of this meditation on disaster testify to the artist's achievements and development over the past decade. We are gratified to help bring this superb new work to fruition as one of the first commissioned artworks jointly produced by the New Museum of Contemporary Art, the Museum of Contemporary Art, Chicago, and the Hammer Museum, Los Angeles, in an alliance known as the Three M Project.

The purpose of our institutional collaboration is to bring emerging international artists to center stage through touring exhibitions and accompanying publications. Each initial project of Three M is directed by one of the institutions—Mik by the New Museum, Fiona Tan by the MCA, and Patty Chang by the Hammer Museum—and will be shown at all three venues over the next year. I would like to thank Dan Cameron, Senior Curator at Large, for proposing and overseeing **Aernout Mik>Refraction**.

For the presentation of **Refraction**, we are most grateful to the American Center Foundation; the Peter Norton Family Foundation; the Mondriaan Foundation, Amsterdam; and the Consulate General of The Netherlands, New York; their generous support made this extraordinary collaboration, commission, and publication possible.

Lisa Phillips
Henry Luce III Director

6

Acknowledgments

The idea of presenting an Aernout Mik exhibition at the New Museum had been percolating for years, and it is particularly gratifying that its realization takes the form of a newly commissioned work under the aegis of a collaborative initiative among the New Museum, the Museum of Contemporary Art, Chicago, and the Hammer Museum, Los Angeles. I feel confident that **Refraction** will tap into a new and expanded audience for Mik's remarkable work, and I am deeply indebted to the artist for giving us the opportunity to share this important new creation with viewers from coast to coast.

When the curatorial teams of our three museums began working on this unique collaboration, we were not quite sure how to proceed. I am grateful to Elizabeth Smith, James W. Alsdorf Chief Curator, at the MCA; and Russell Ferguson, Deputy Director for Exhibitions and Programs and Chief Curator, at the Hammer for providing a very supportive intellectual environment in which those initial discussions could take place. I would also like to acknowledge the creative initiative and drive of Lisa Phillips, Henry Luce III Director of the New Museum; Anne Philbin, Director of the Hammer; and Robert Fitzpatrick, Pritzker Director at the MCA, who have helped transform the idea into a reality.

This exhibition is practically tailor-made for the particular strengths of the New Museum curatorial team, and I am thankful to numerous colleagues for their eminent capabilities in meeting such challenges. Melanie Cohn, who oversees catalogue production for the Museum, has smoothly navigated and finessed every aspect of bringing about this handsome publication. Keith Johnson, whose exhibition layout and installation management are essential to the success of all our exhibitions, has keenly translated Mik's concepts into three dimensions. Hakan Topal has once again brought his special expertise in creating adaptive interfaces between artists and technology to the particular challenges of this installation. And we are thankful to ProAV of Helsinki for providing the equipment and computer interface for **Refraction**.

I would also like to acknowledge the visionary catalogue design of Paul Carlos, who wonderfully tailors his choices and materials to the particular philosophy of the artist with whom he is working.

Dan Cameron
Senior Curator at Large, New Museum of Contemporary Art

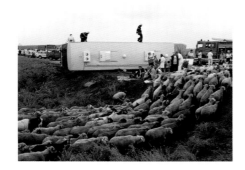

I ♥ Rescue Worker

Dan Cameron

Catastrophes are a fundamental part of the collective ecology of the human race. Without exactly waiting for the next major disaster to come along, we are, nonetheless, always subliminally aware that before long one will occur: manmade or natural, from the ocean or outer space, and with casualties measured in thousands or tens of thousands. According to the Big Bang theory, the origins of the universe and of life itself can be traced back to the crucible of a single, unimaginably powerful cataclysm. At the very least, one aspect of civilization as we know it is measured by our forebears' efforts to bolster themselves, after the fact, from the worst results of the most devastating events that have shaped human history.

By now, it has become a truism that disasters can also bring out the very best in human nature. We may not be putting much ongoing thought into how to conquer, in the long term, poverty and disease in the world's poorest countries, but whenever disaster hits on a monumental scale, we immediately transform into a culture of altruists, digging deeper into our pockets and pantries to provide for those who have been suddenly left without. The everyday limits of our empathy give way to genuine feelings of heartbreak over the fate of a nameless three-year-old orphan in a news photo, whose parents were swept away by the recent Indian Ocean tsunami. This outpouring of sympathy and charity, while inarguably a laudable response, nevertheless brings up an important question: Just what is it about a disaster that has the power to transform us into the idealized versions of ourselves that everyday life does not encourage or permit?

In Aernout Mik's newest work, **Refraction** (2004), all the trappings of the disaster scene appear to be present and accounted for. We are in a part of Romania where the landscape is flat and sparsely inhabited, and the horizon a scraggly line set unnervingly high. Just prior to our arrival on the scene, a bus has flipped over on its side, and crews of police, medics, and other first responders are already diligently making their way through the crash site, digging at rubble and picking through the interior of the bus. It could well be a holiday weekend, judging from the long queue of cars backed up behind the bus and the lack of traffic headed in the opposite direction. At the front of the line, anxious drivers mull about, wearing concerned looks on their faces. Everyone has his or her assigned role to play, and as the minutes pass and the rescue drags on with no apparent change in status, even the ones who have nothing to do but wait are content to show just how good they are at it.

If at first we don't really take notice of the complete absence of victims from this accident, that might be because the work's machinations come as a kind of relief from the parade of carnage generated by an ordinary night's news and entertainment. Perhaps we automatically assume that the camera is just being discreet in the way it pokes through the wreckage, tracking the earnest "rescue" efforts while somehow managing to avoid having even a single smear of blood or pain-stricken face enter our field of vision. Or perhaps the victims have already been taken away, and they weren't really so badly hurt—there are, after all, some people seated on the ground with blue blankets thrown over their shoulders. Perhaps before we have singled out the gore-free dimension of the scene as being somehow peculiar, we might be starting to wonder about the muffled behavior of the performers themselves, who all seem to be wearing the appropriate uniforms and using the sort of body language one would expect from well-trained professionals, but who aren't really engaging with one another except through a shell of ritualized behavior.

By the time the sheep and pigs arrive on the scene, we aren't so preoccupied with the absent victims anymore. This being the open countryside, seeing a herd of sheep wander onto an accident scene is not in itself so strange; what is disconcerting is that no one among the throngs of people seems to be responsible for the herd. A man in military drab with a German shepherd is keeping his dog on a short leash, but the two of them seem engaged in checking the side of the road for something more lethal. In fact, not only is no one acting in any way to impede or drive the sheep, but it soon becomes apparent that no one is paying them much attention at all. The sheep are, for all intents and purposes, invisible to the whole rescue team, who seem to occupy another perceptual realm entirely. The pigs, for their part, also seem to treat this momentary lapse in their routine as something quite easily navigable, as they root through the roadside for their own edible treasures.

Were it not for the animals, we might find a way to rationalize the oddness of this victimless disaster and the disengaged attitude of the first responders. But the fact that not even the bizarre appearance of these animals is able to affect a response in the workers makes us wonder if their "detachment" is more than just professional. Mik is hoping that most of us will identify more with the sheep and pigs, who manifest a clear will and intent regardless of any obstacle, than with the humans in **Refraction**, who seem utterly passive, powerless, and ineffectual. The discrepancy of having these animals within the scene also begs the question of what symbolic meaning they might have in the artwork. It would no doubt be stretching the artist's intentions to suggest that these creatures are in fact the souls of our departed brethren from the accident, but such thoughts cannot be too far from the imaginings of a seasoned viewer of independent film. Whatever their symbolic intent in Mik's piece—and it is no doubt many things, and none of them—the animals are perfectly at home wherever they find themselves, adapting effortlessly to any circumstance.

– – –

The cognitive starting point for most of Mik's video installations is a premonition of impending social collapse. No sooner do we enter one of his sculptural spaces than we find ourselves confronted with persuasive evidence of a breakdown in order: an earthquake, a stock market collapse, the muddy aftermath of an outdoor rock concert. In most of these works, a limited attempt has been made to duplicate certain of the conditions surrounding the event, not so much to fool the spectator as to create a further disconnect between the event and its repercussions. Mik's staged moments of faux crisis, which tend to contain just enough reality to confound our disbelief, are composed in such a way as to draw our attention to the increasingly universal human experience of indifference toward one's fellow human beings.

Although Mik often develops narratives based on semi-imagined catastrophes, his work manifests a detachment driven in part by the artist's distrust of how special effects–based "realism" functions in most Hollywood movies, where the measure of success of an entertainment lies in the degree to which the action fully overshadows any portrayal of the participants' capacity to respond to it. By contrast, Mik is interested less in depicting the cataclysm that seems to be unfolding at the heart of a given narrative than in examining the effects such events have on human behavior. What most of the characters in Mik's previous videos have in common is the stricken, even shell-shocked look of people not yet able to fully absorb the impact of what has just befallen them. Their dazed, detached wanderings and their compulsion to pull a veil of normalcy over the face of chaos come across as all the more disturbing when considered in relation to the staged artificiality of the disasters themselves.

Things are a bit different in **Refraction**, if only because its scenario is so much more elaborate than its predecessors. Not only do all the vehicles and equipment in the film appear to be authentic, but the sheer number of actors onscreen at any given time creates a spectacle of human

solidarity whose realization is belied only by the strange ennui that hangs over everybody, from emergency personnel to stranded motorists. The action in **Refraction** takes place over a longer stretch of time (30 minutes) than is typical of Mik's work, and with the obtuse angling of the projection wall toward the viewer, which suggests the overall shape of the crashed vehicle onscreen, the effect of the interpersonal buffer zone between characters is dispersed, or delayed. Our engagement with this work is more akin to a conventional movie-going experience, although, like all new arrivals on an accident scene, we, too, want to get as close-up an inspection as the occasion permits.

As a society we have become so deeply accustomed to social barriers that, one could argue, we no longer know how to participate in activities and events staged for us. This is not to say that respecting ity in emergency situations is a bad thing, or ally trying to assume control over an unmana is a good thing. But by presenting us with the a crisis situation in which nothing too terrible occurred, Mik is also drawing our attention to when faced with a sudden, unplanned void in space, when thrown out of a familiar context, m relatively unprepared to be ourselves and to fo ural instincts. And so Mik's rescue workers go quietly heroic but staged tasks, shielding us fro of what has already happened, while their ve serves as a nagging reminder that there is no tect us the next time a real disaster comes alon

rative to his videos per se, I will focus instead on how they are integrated into his environments, since video is, after all, just one element of Mik's larger scheme.

A striking characteristic of Mik's video installations is that they do not turn the gallery into a black box. He does not use traditional cinematic tropes such as larger-than-life-size projections and surround sound in dark rooms to envelop the viewer in a disembodied, purely visual experience. Rather, his practice straddles the boundaries between sculpture, performance, architecture, and video, "aiming to connect the moving image with the actual space of the gallery."[3] Mik finds the moniker "video artist" limiting, preferring to be called "a sculptor who employs video along with other media to present a variety of shifting experiences."[4] In addition to setting up architectural and spatial interventions within his video installations, Mik frustrates our preconditioned expectations vis-à-vis the moving image by disconnecting exterior behavior from interior motivations, and actions from reactions.

Since the early 1990s, Mik has mixed live performance featuring actors, animals, and puppets with live-feed video and video projections, moving screens, and animated props within installation architecture that is deliberately designed to address viewers on different levels simultaneously—conceptual, psychological, and physical. These spaces often feature rounded corners, walls placed at anything but right angles, tightening and expanding corridors, lowered ceilings, undulating floors, and mirrors. Within these tightly controlled environments, rear-projection screens are seamlessly sunk into temporary walls. Slightly smaller than life size, the projected images touch the floor, acquiring weight and thereby emphasizing the sculptural aspects of the installations. To further accentuate this dimension of the work, Mik's video loops are usually devoid of sound, creating a strong overlay between the fictional and the

Reversal Room, 2001.

actual physical space of
and light in the gallery ir
By overlapping in this w.
into one expanded socia
Mik sets up a physical re
the projection. Into this c
introduces quasi-docum
behavior, which at first a
day life—a crowd at a roc
in a garage, guards in a r
dent, however, that the p
the influence of some ma
the framed image. His e
people who are disconn
they are involved in utt
both ordinary and myst
dialogue, and characteriz
it difficult to distinguish
is acted, while beginning
notic stream of images.
characters and situations
own focus. Eschewing the
montage of Hollywood fi
manner more reminisce
ema, when a static appa
of capturing the action v
the correlation of what
and between the frames
engage with, and so he c
happens in close contac
same time almost touchi
completed in 2001, is a g
strategies link into a mult

Reversal Room is one of t
installations, similar in sc
recent **Dispersion Room**
Reversal Room, howeve
ferent scenes: one taking

as ambient sound
video projections.
d depicted spaces
logical landscape,
en the viewer and
ial arrangement he
ictions of human
scenes from every-
en standing around
soon becomes evi-
's videos are under
or event outside of
nes are filled with
one another, as if
ntained activities,
pped of narrative,
rtist's script makes
at is real and what
issolve into a hyp
locations replace
ers left to find their
ns of narrative and
es the camera in a
arly history of cin-
ot always capable
ame. It is precisely
ng inside, outside,
nts his audience
arallel world which
ifferent but at the
's **Reversal Room**,
le of how all these
vironment.

nore complex video
ber (2000) and the
What distinguishes
uxtaposes two dif-
Chinese restaurant

actual physical space of the viewer as ambient sound and light in the gallery infiltrate the video projections. By overlapping in this way actual and depicted spaces into one expanded social and psychological landscape, Mik sets up a physical relation between the viewer and the projection. Into this complex spatial arrangement he introduces quasi-documentary depictions of human behavior, which at first appear to be scenes from every-day life—a crowd at a rock festival, men standing around in a garage, guards in a museum. It soon becomes evi-dent, however, that the people in Mik's videos are under the influence of some manipulation or event outside of the framed image. His entropic scenes are filled with people who are disconnected from one another, as if they are involved in utterly self-contained activities, both ordinary and mysterious. Stripped of narrative, dialogue, and characterization, the artist's script makes it difficult to distinguish between what is real and what is acted, while beginning and end dissolve into a hyp-notic stream of images. Extras and locations replace characters and situations, with viewers left to find their own focus. Eschewing the conventions of narrative and montage of Hollywood films, Mik uses the camera in a manner more reminiscent of the early history of cin-ema, when a static apparatus was not always capable of capturing the action within its frame. It is precisely the correlation of what's happening inside, outside, and between the frames that Mik wants his audience to engage with, and so he creates "a parallel world which happens in close contact with us, different but at the same time almost touching us."[5] Mik's **Reversal Room**, completed in 2001, is a good example of how all these strategies link into a multilayered environment.

Reversal Room is one of the artist's more complex video installations, similar in scope to **Lumber** (2000) and the recent **Dispersion Room** (2004). What distinguishes **Reversal Room**, however, is that it juxtaposes two dif-ferent scenes: one taking place in a Chinese restaurant

Reversal Room, 2001.

and the othe
simultaneou
actors or ex
installation c
lessly incorpo
that are insta
this way **Rev**
with slowly r
feel like we ar
Starting out i
times betwee
lated kitchen
suspended ov
bulbs make a
the restauran
kitchen sessic
in which peo
frames. For th
conceived th
of **Reversal F**
integral part,
At Cornell, v
passageway
dead-end cor
entered and
corridor. Con
are interdepe
try to integra
the 'fictional'
way that you
the other be
this relations
era shot to th
kitchen sequ
pan, in the re
out of one ar
shape of the
circular to a
ing organism

and the other in a kitchen. Each scene was recorded simultaneously on five cameras and used untrained actors or extras and partially constructed sets. The installation consists of five transparent screens seamlessly incorporated within shoulder-high movable walls that are installed within a pentagonal construction; in this way **Reversal Room** completely surrounds viewers with slowly rotating, synchronized tableaux, making us feel like we are situated right in the middle of the events. Starting out in the restaurant, the projections switch six times between the dining room and the seemingly unrelated kitchen. In sync with the video sequences, lights suspended over the enclosed space switch as well. Yellow bulbs make actual corridors visible during the scenes in the restaurant, while a central blue light is paired with the kitchen sessions, turning them into a panoramic tableau in which people move in a circle, passing in and out of frames. For the installation at the Johnson Museum, Mik conceived the piece differently from previous versions of **Reversal Room**, in which one-way mirrors played an integral part, complicating spatial relations even further. At Cornell, viewers were led through a narrow, angled passageway into a central enclosure, from which two dead-end corridors of different depths branched off. One entered and exited the viewing space through the same corridor. Commenting on how images and architecture are interdependent in his installations, Mik has noted: "I try to integrate the experience of the actual space and the 'fictional' experience of the video projection in such a way that you cannot tell exactly where the one stops and the other begins."[6] In **Reversal Room** he accomplishes this relationship by linking the construction of the camera shot to that of the installation architecture. While the kitchen sequence was shot exclusively in a 360-degree pan, in the restaurant the camera slowly zooms in and out of one area of the dining room. Consequently, the shape of the enclosure itself appears to change from a circular to a star pattern, seeming to become a breathing organism.

In this wa
space of th
lery, makir
tionship to
don't mea
artist has
the idea o
who can be
and other
action on
into an in
conventio
structure
us privileg
body expe
here, imm
16 bodies are
matter wh

Andrea Insel
Herbert F. Jo
organized nu
porary art.

1 In 2003, th
 was the fir
 installation
2 Aernout M
 (Cleveland
3 Mik, in an i
 (Barcelona
4 Mik, in a pr
 Herbert F.
 York, on Fe
5 Gili intervi
6 Mik, in an i
 exhibition
 Spaces of
 Esposizion
 arte/testi/
7 Mik, quote
 Reversal

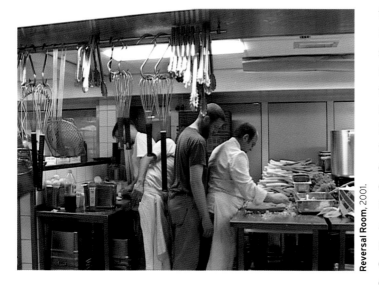

Reversal Room, 2001.

In this way, **Reversal Room** coalesces the fictitious space of the film with the real, physical space of the gallery, making viewers more aware of their bodies in relationship to their environment and to other viewers. "I don't mean to dismiss self-awareness altogether," the artist has admitted, "just the part of it that promotes the idea of an individual as an independent creation who can be looked at as separate from his environment and other people and objects in space."[7] Mik combines action on film, camera work, and spatial construction into an interlocking system. He thus destabilizes the conventional cinematic techniques spectators use to structure reality, reversing our idea that vision grants us privileged access to the world. Mik proposes a whole-body experience in highly conceptualized environments; here, immersed in representations of simultaneity, our bodies are able to connect across different realms, no matter what cultural background we bring to them.

Andrea Inselmann is curator of modern and contemporary art at the Herbert F. Johnson Museum of Art at Cornell University, where she has organized numerous exhibitions of national and international contemporary art.

Reversal Room, 2001.

1 In 2003, the Herbert F. Johnson Museum of Art at Cornell University was the first American museum to add one of Aernout Mik's video installations, **Reversal Room**, to its permanent collection.
2 Aernout Mik, quoted in Jeffrey D. Grove, **Aernout Mik**, exh. brochure (Cleveland: Cleveland Museum of Art, 2003), unpaginated.
3 Mik, in an interview with Marta Gili in **Aernout Mik**, exh. cat. (Barcelona: Fundació "la Caixa," 2003), 89.
4 Mik, in a public dialogue with the author that took place at the Herbert F. Johnson Museum of Art, Cornell University, Ithaca, New York, on February 5, 2004.
5 Gili interview, 89.
6 Mik, in an interview with Lorenzo Benedetti in conjunction with the exhibition **Gravitá Zero/Zero Gravity: Art, Technology, and New Spaces of Identity**, Fondazione Adriano Olivetti, Palazzo delle Esposizioni, Rome, Italy, 2001, http://televisione.leonardo.it/fnts/arte/testi/gravita0/inglese/Mik-ingl.doc (accessed March 29, 2005).
7 Mik, quoted in Philip Monk, "Languages of Action," in **Aernout Mik: Reversal Room**, exh. cat. (Toronto: The Power Plant, 2002), 26.

out Mik>Refrac

Aernout Mik
Refraction, 2004
DVD; 3 projected images creating a single
4:1 ratio, panoramic image

Co-Direction: Marjoleine Boonstra
Photography: Benito Strangio
Steady-Cam Operator: Jo Vermaercke
Art Direction: Elsje de Bruijn
Production: Dirk Tolman, Jelier & Schaaf
Production Assistant: Anca Munteanu

Thanks to: Cam-A-Lot, Mark Gastkemper,
Petro van Leeuwen (Ultimate), Laurens
Meulenberg, Saga Film (Bucharest),
Traffic, Ynse Ijzenbrandt.

Courtesy carlier | gebauer, Berlin, and
The Project, New York and Los Angeles.

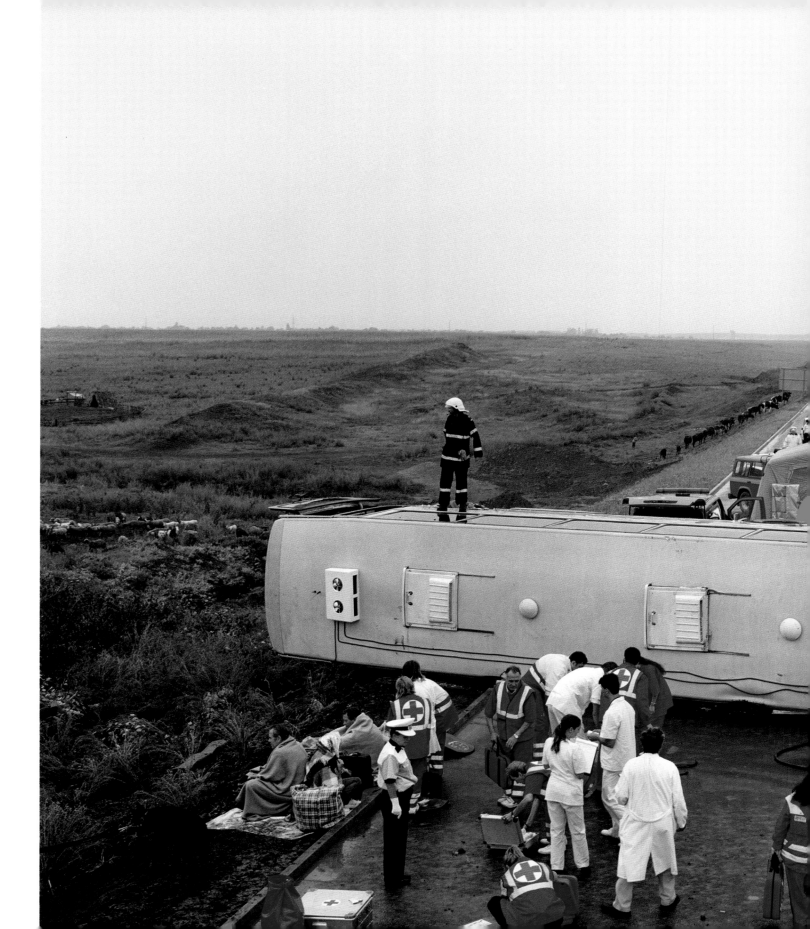

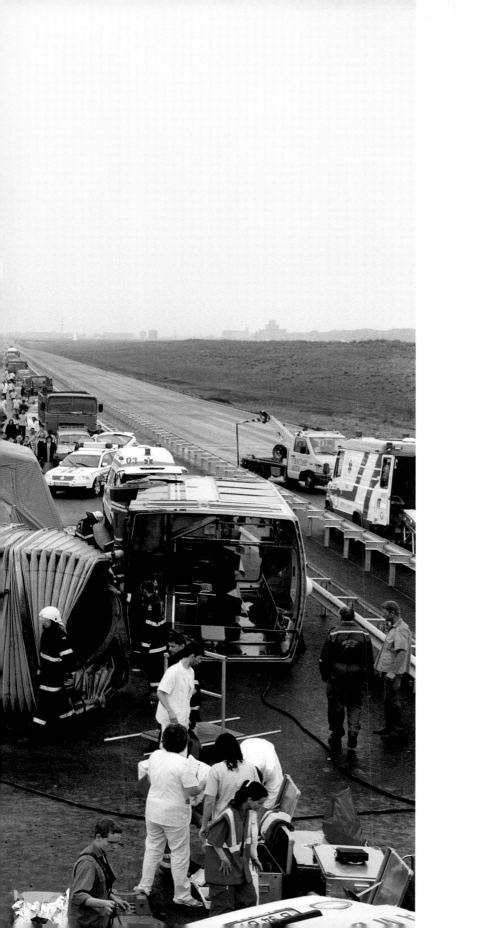

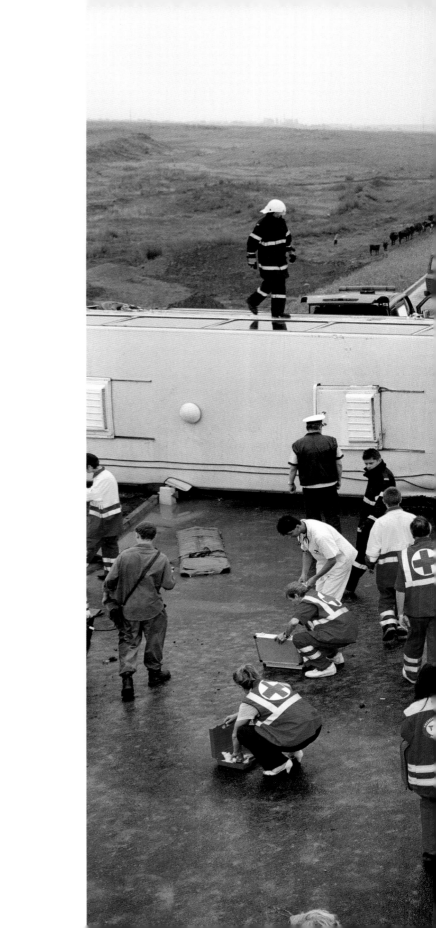

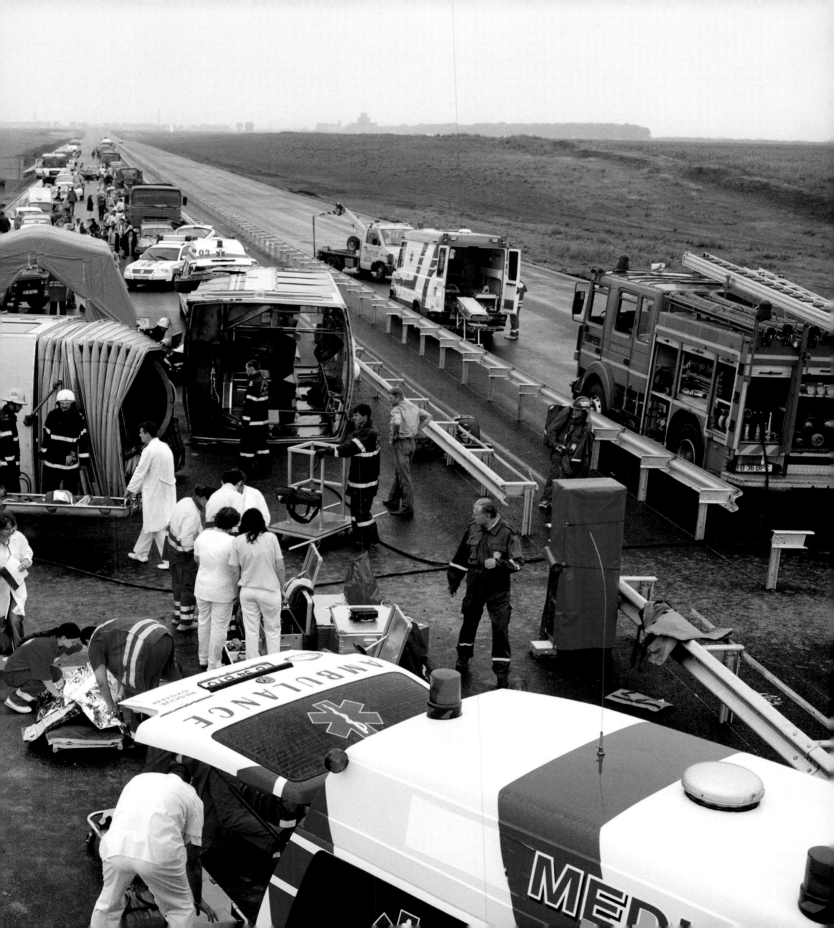

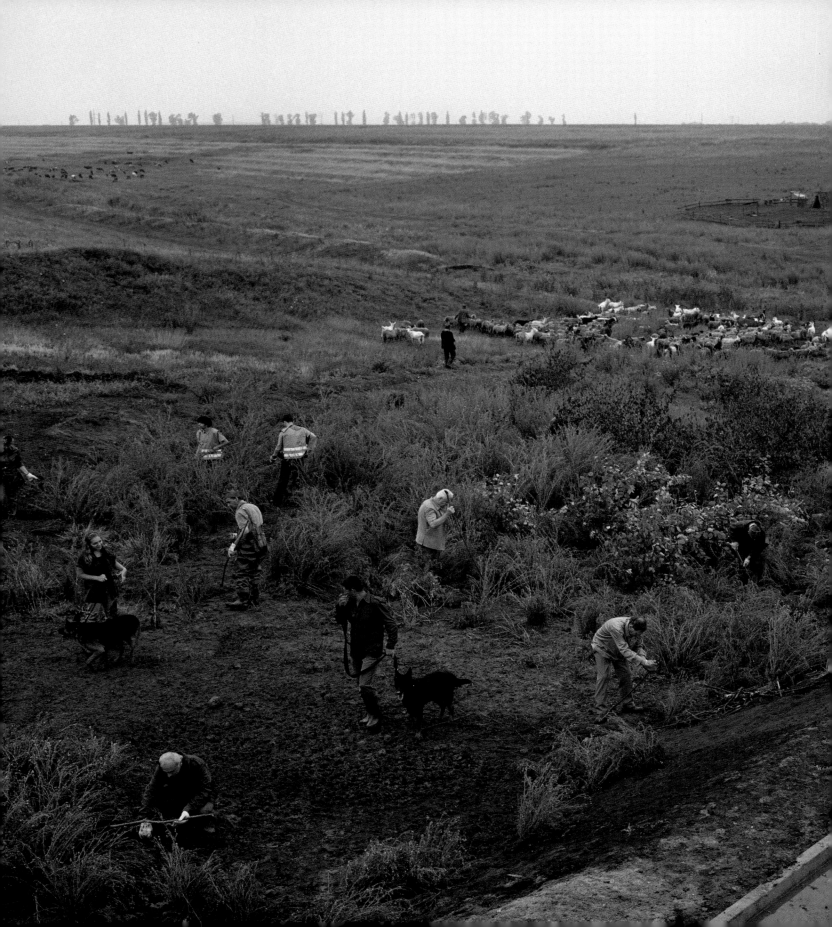

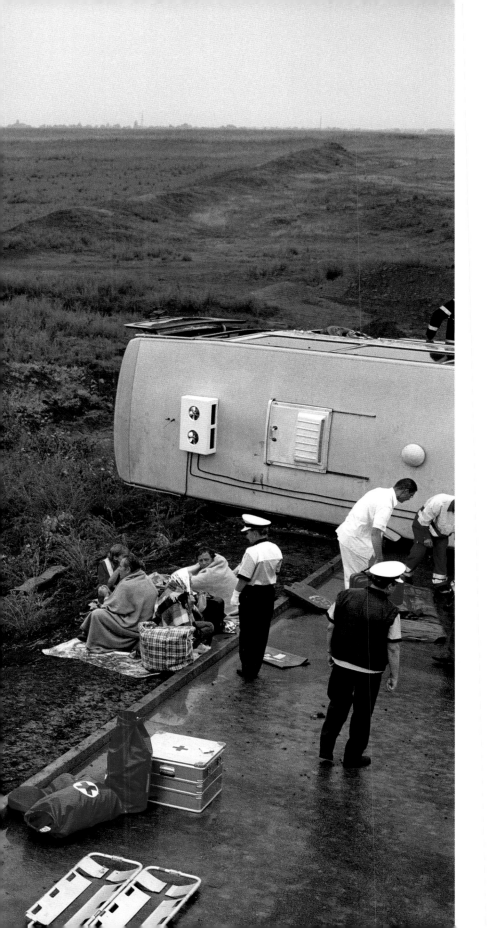

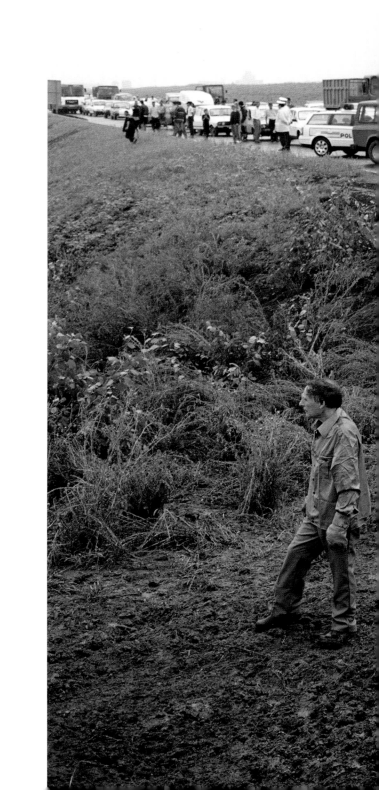

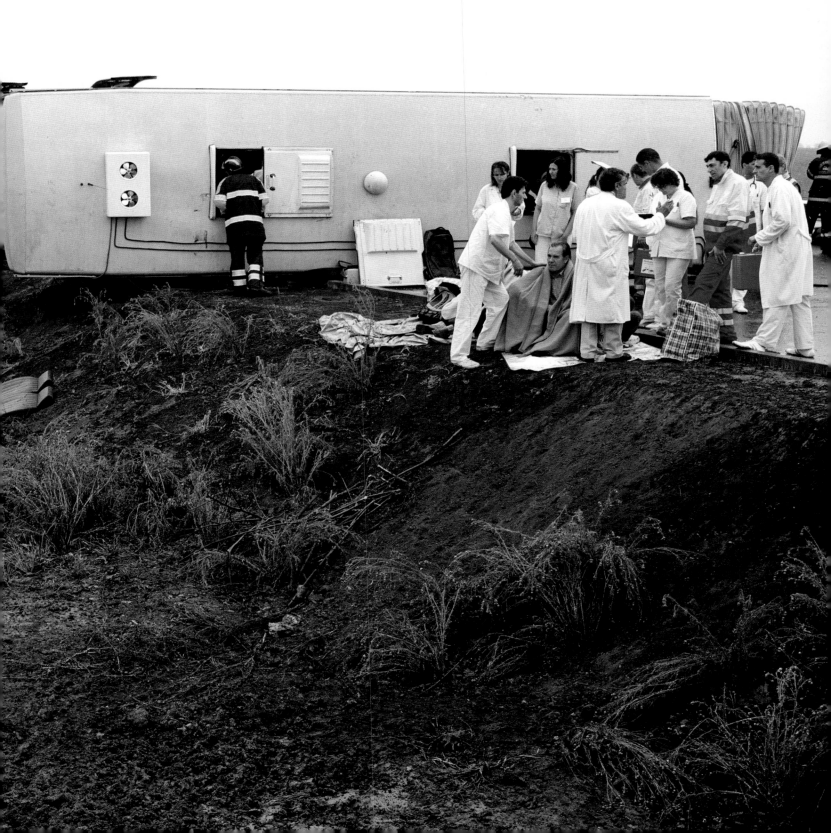

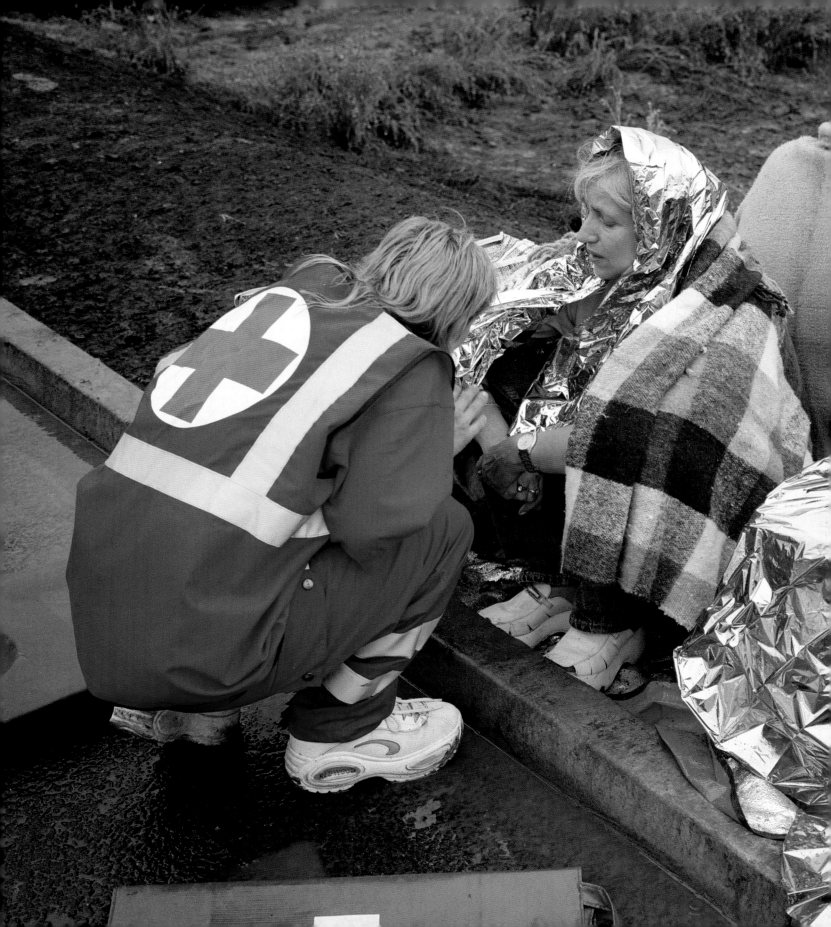

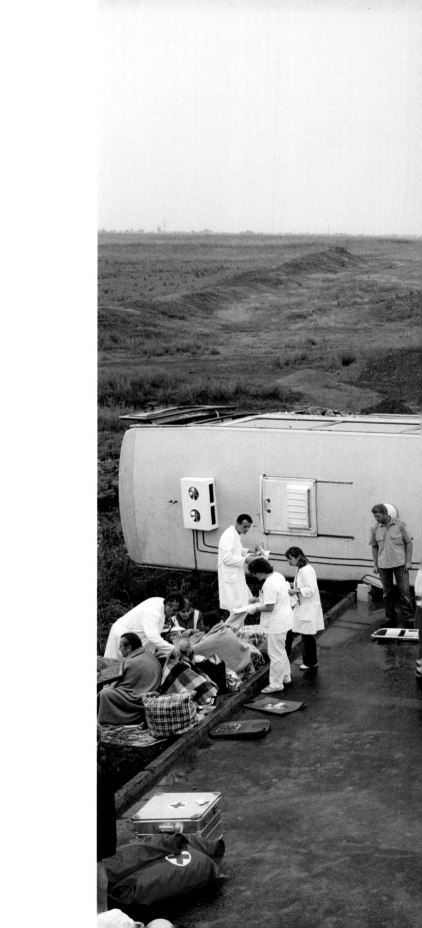

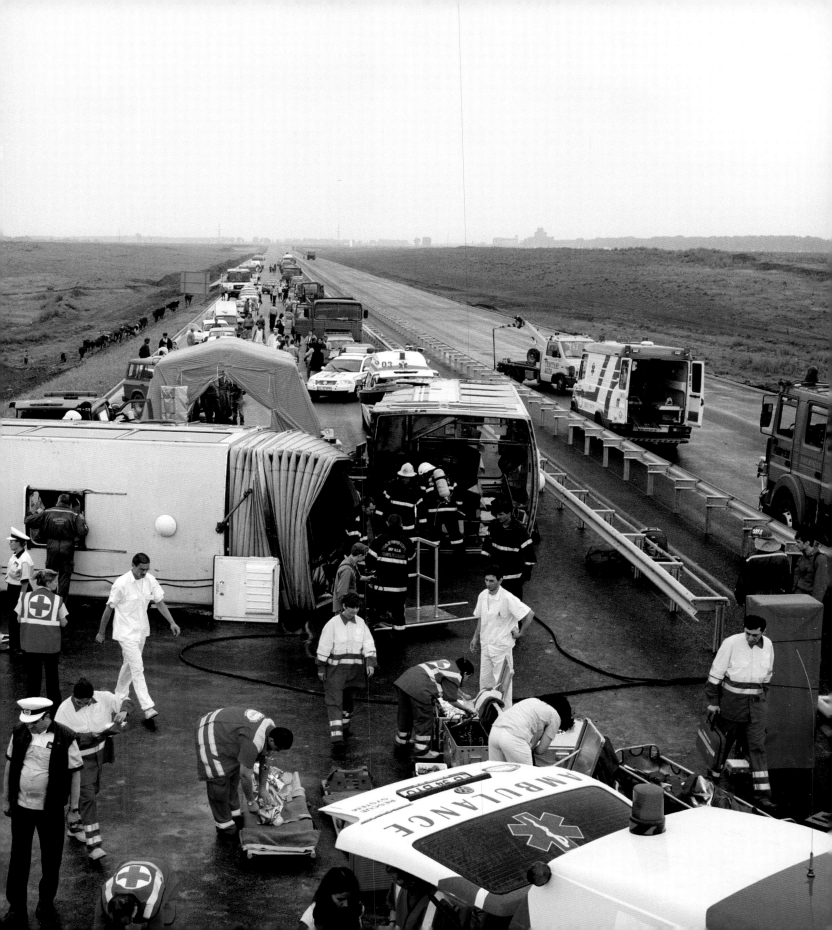

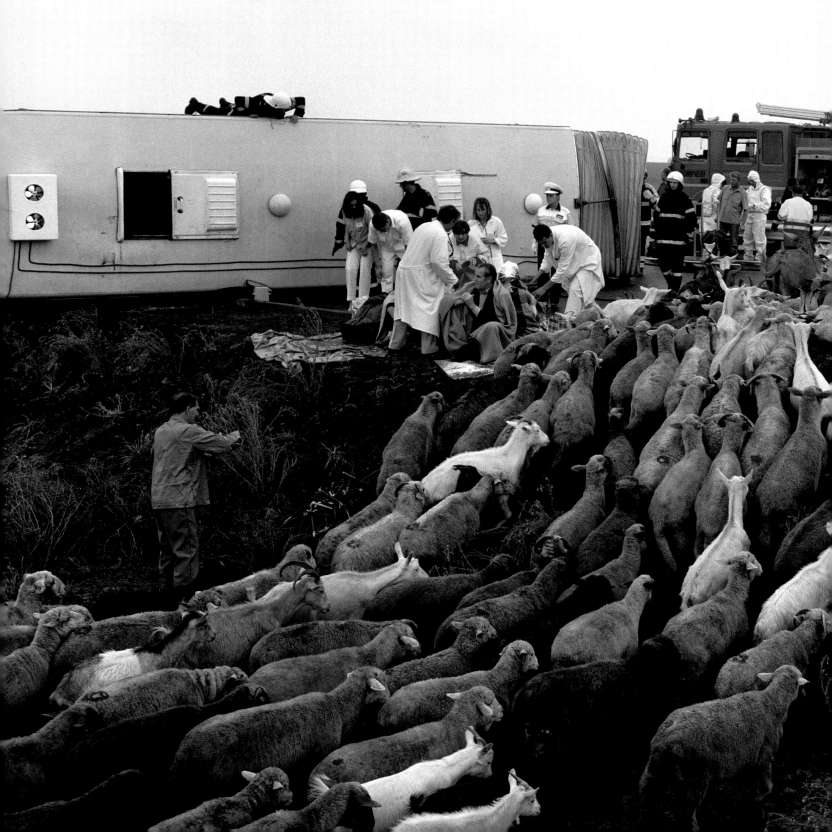

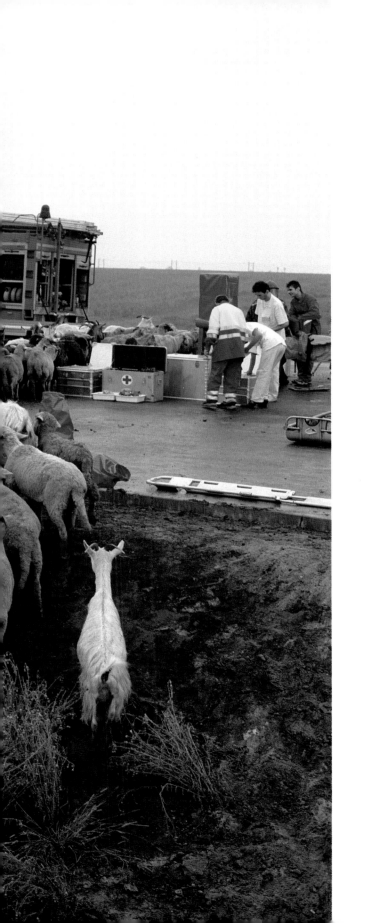

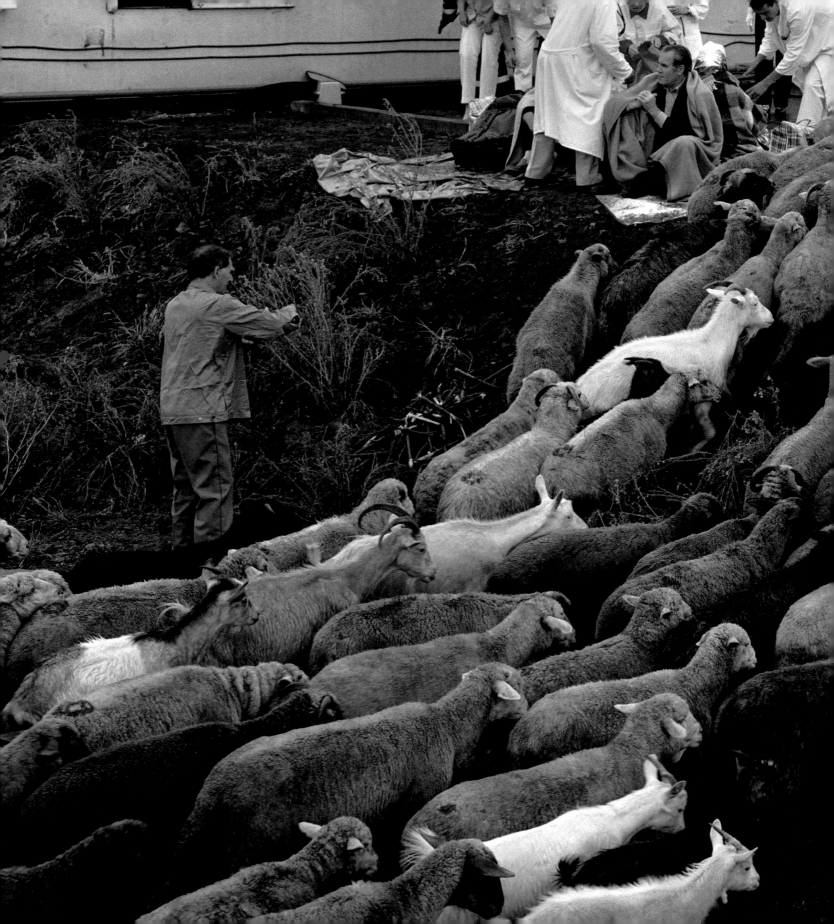

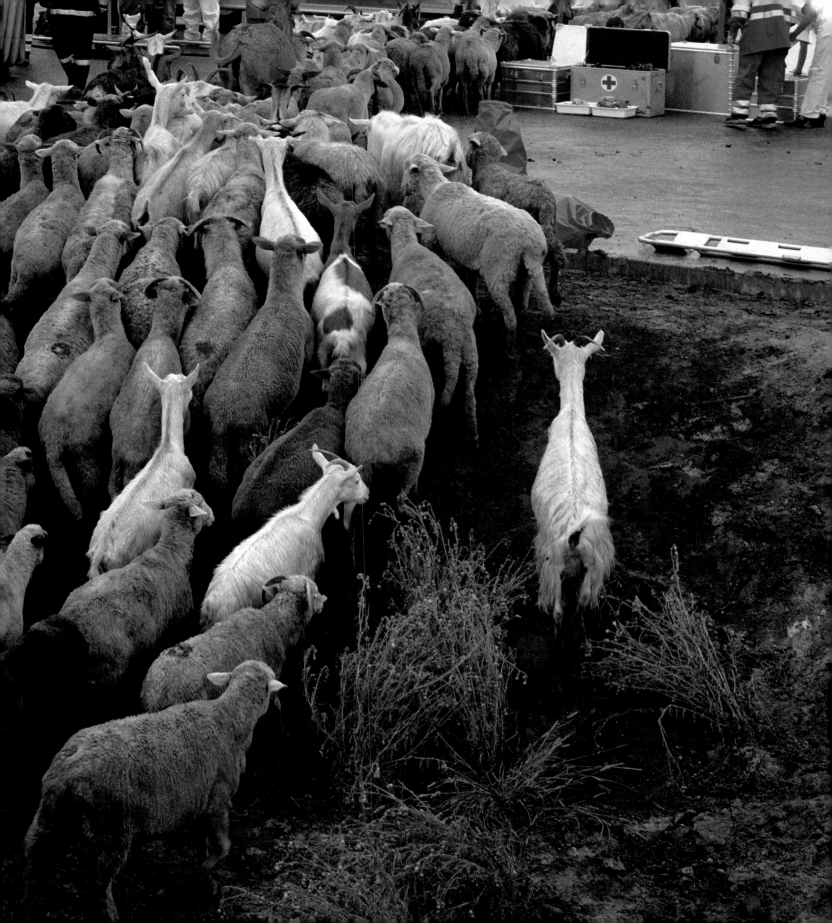

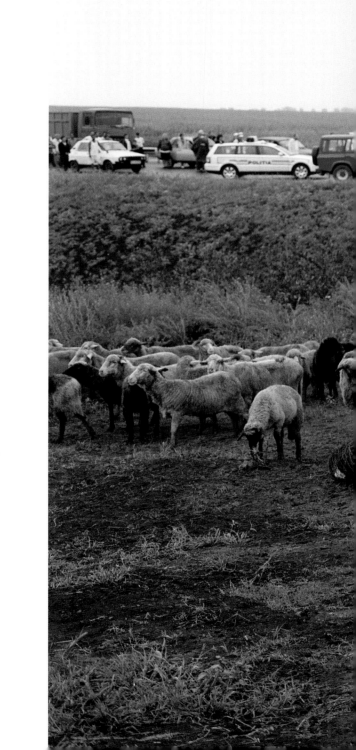

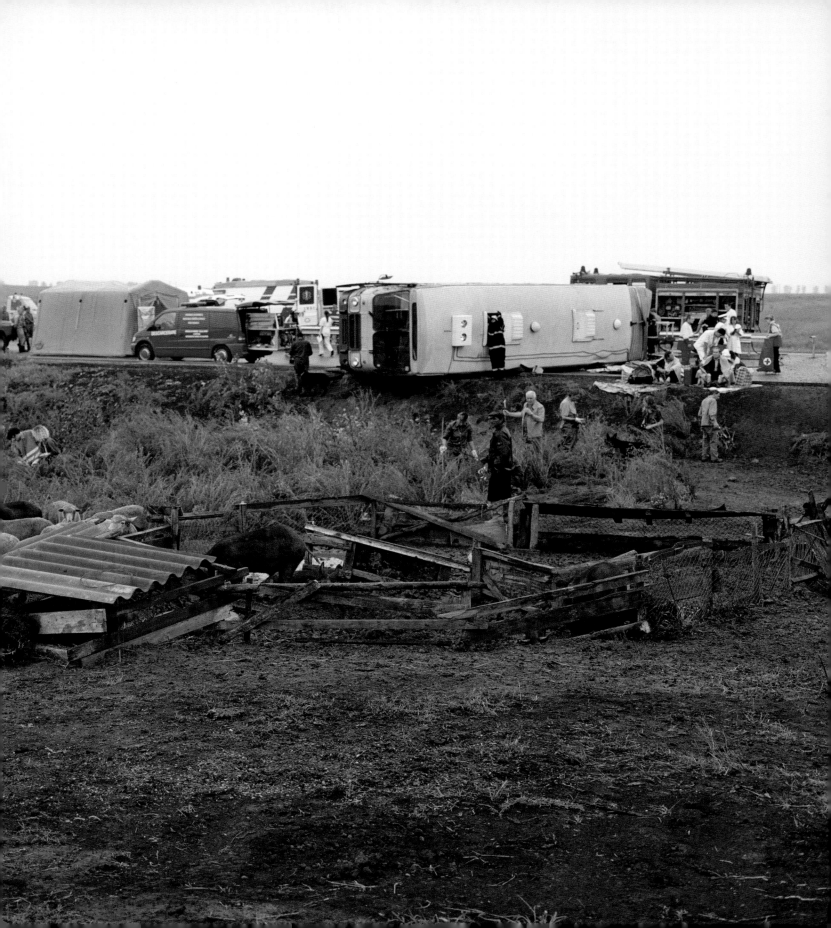

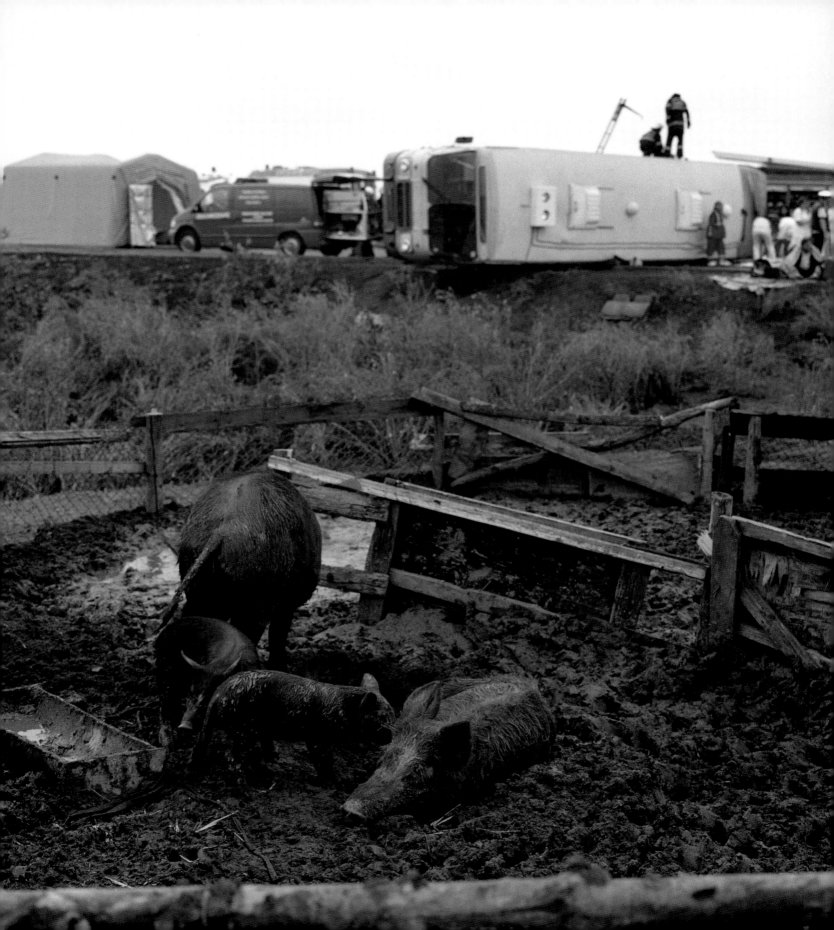

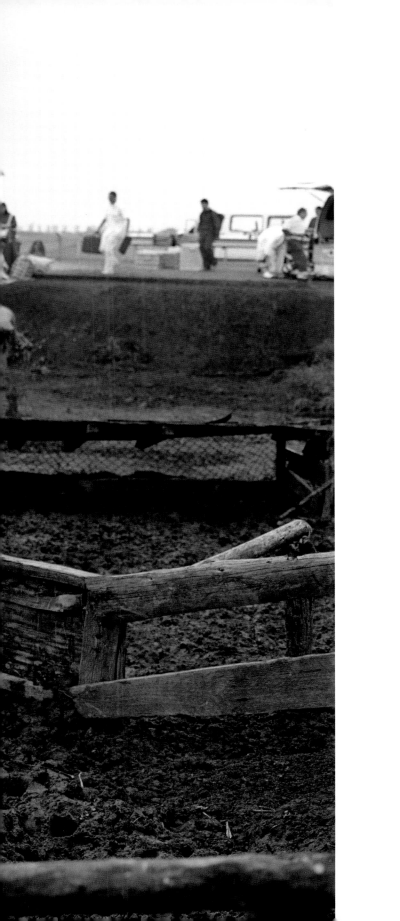

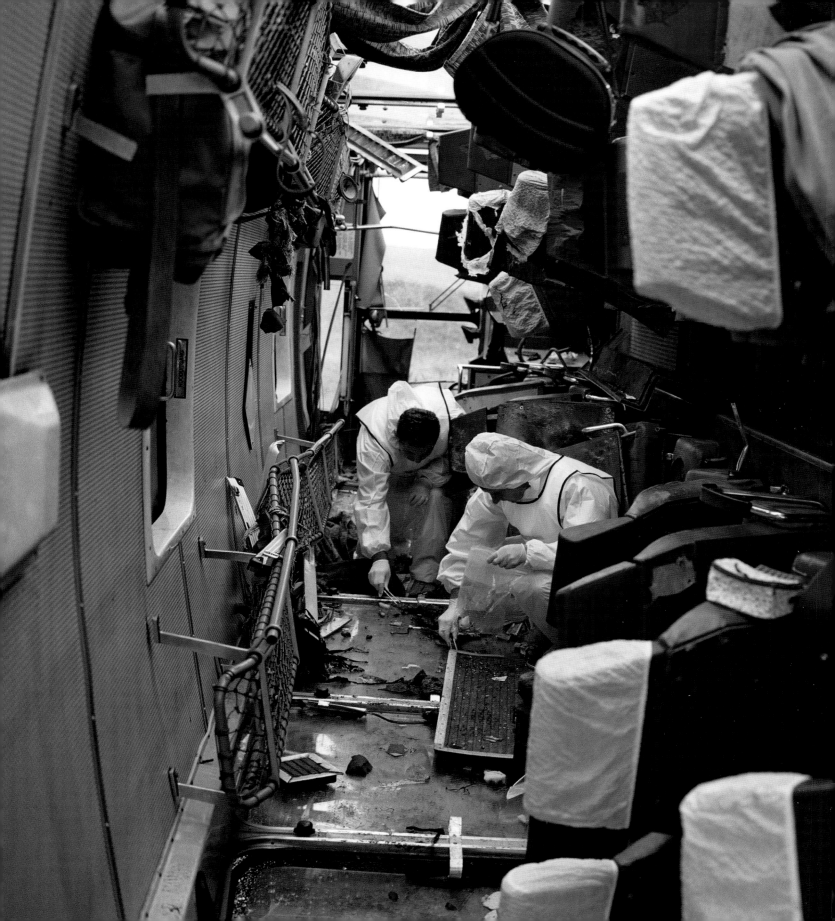

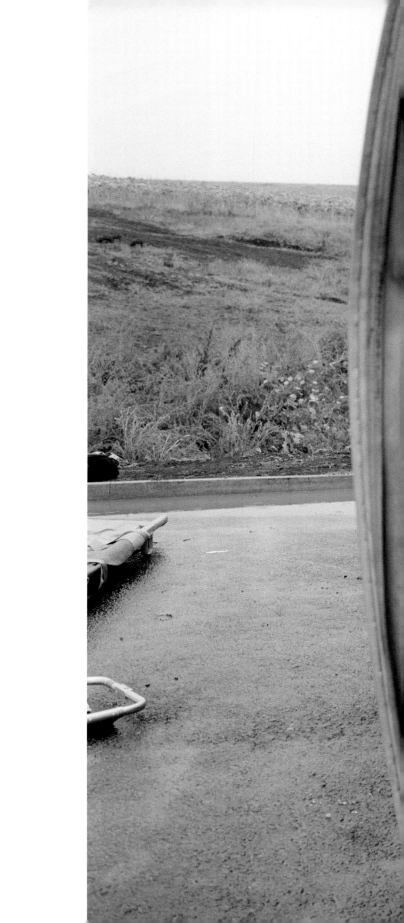

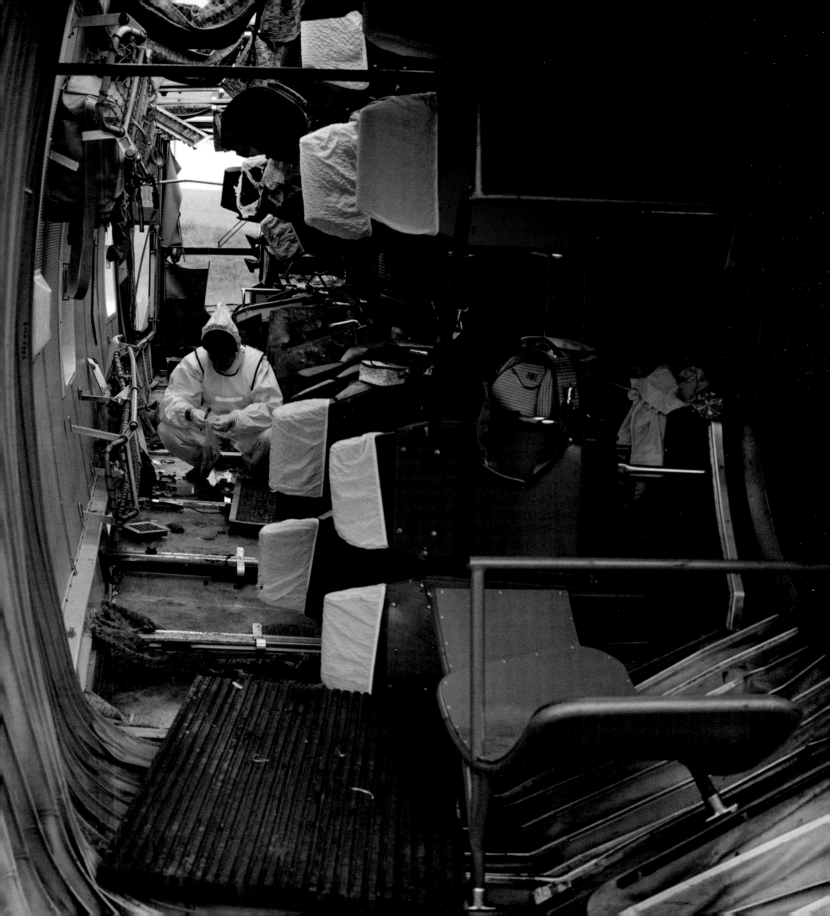

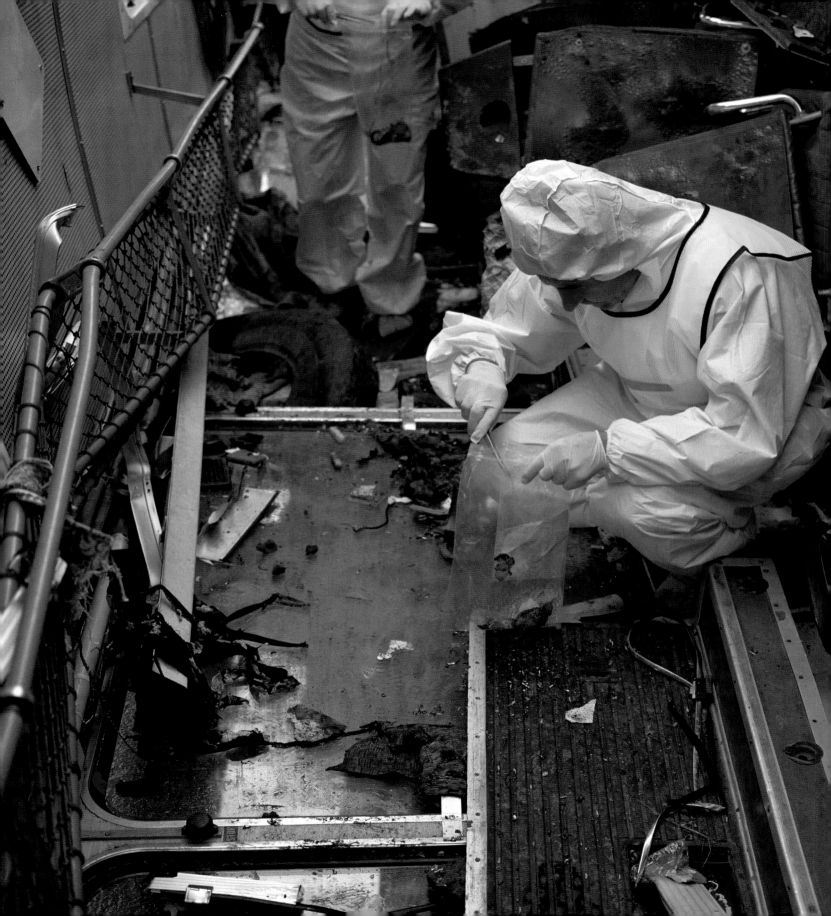

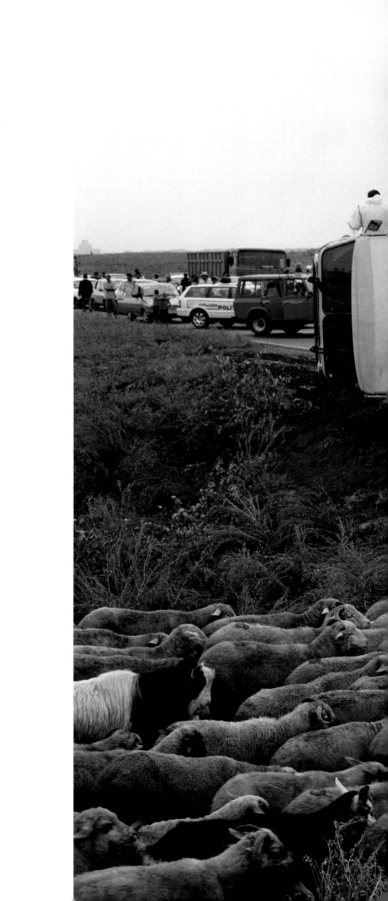

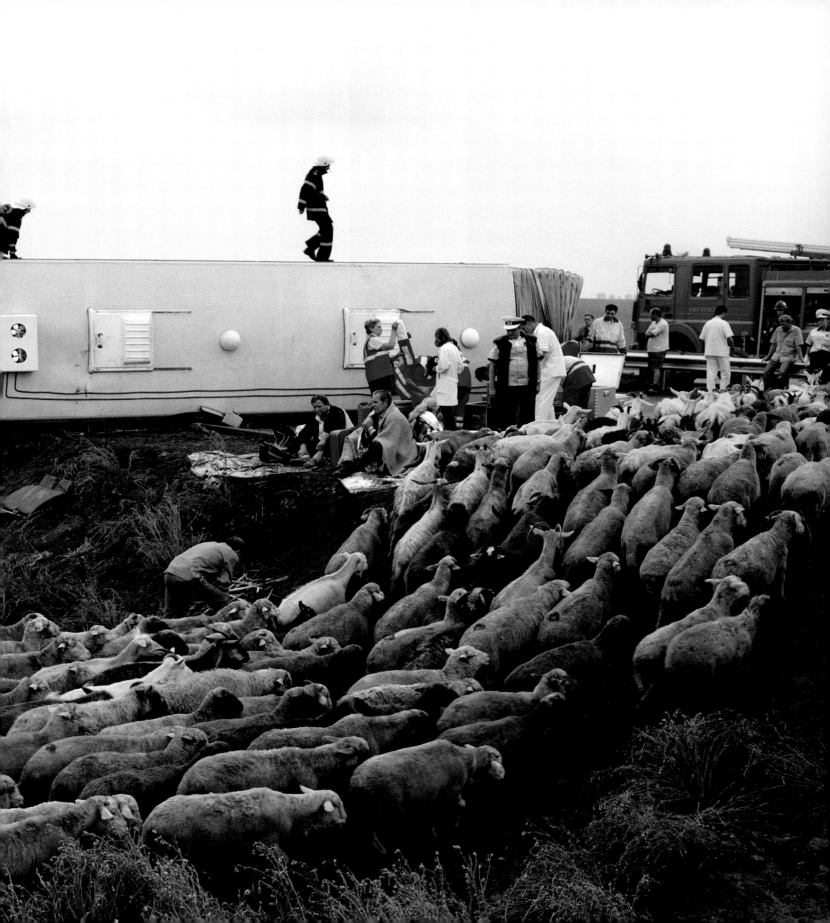

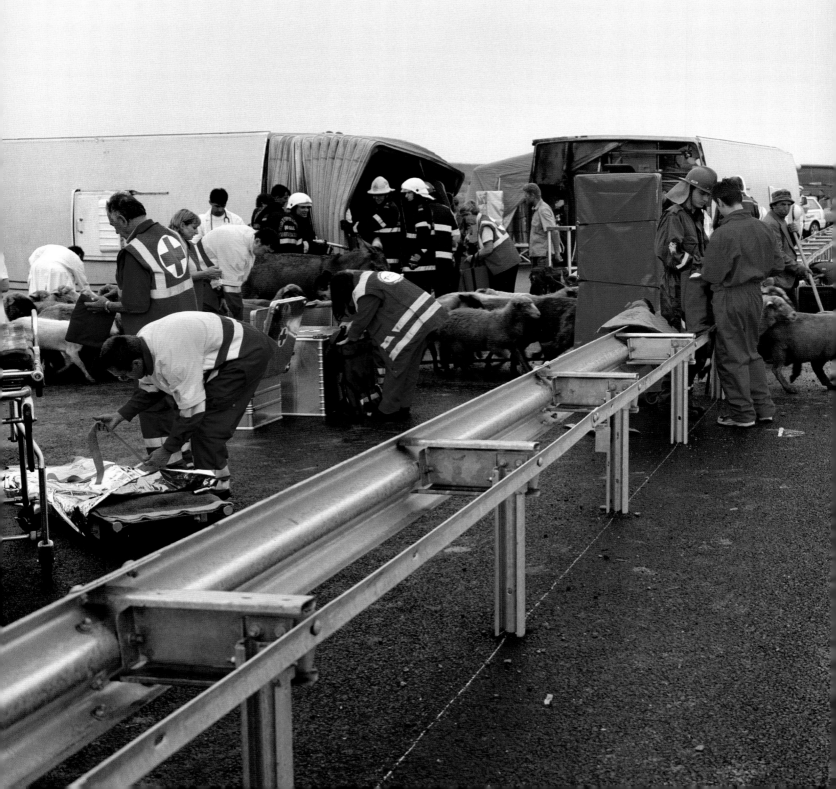

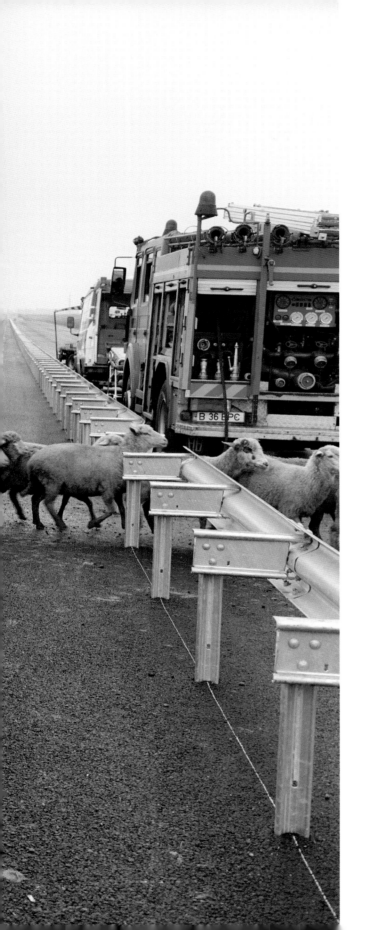

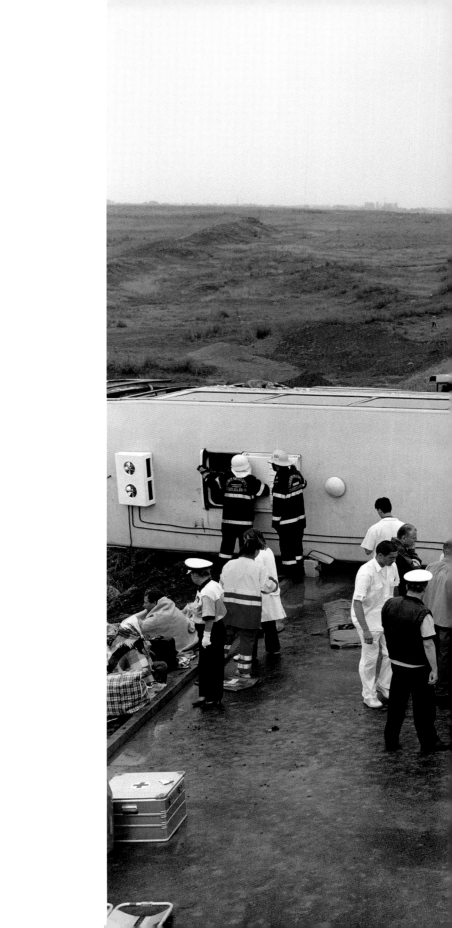

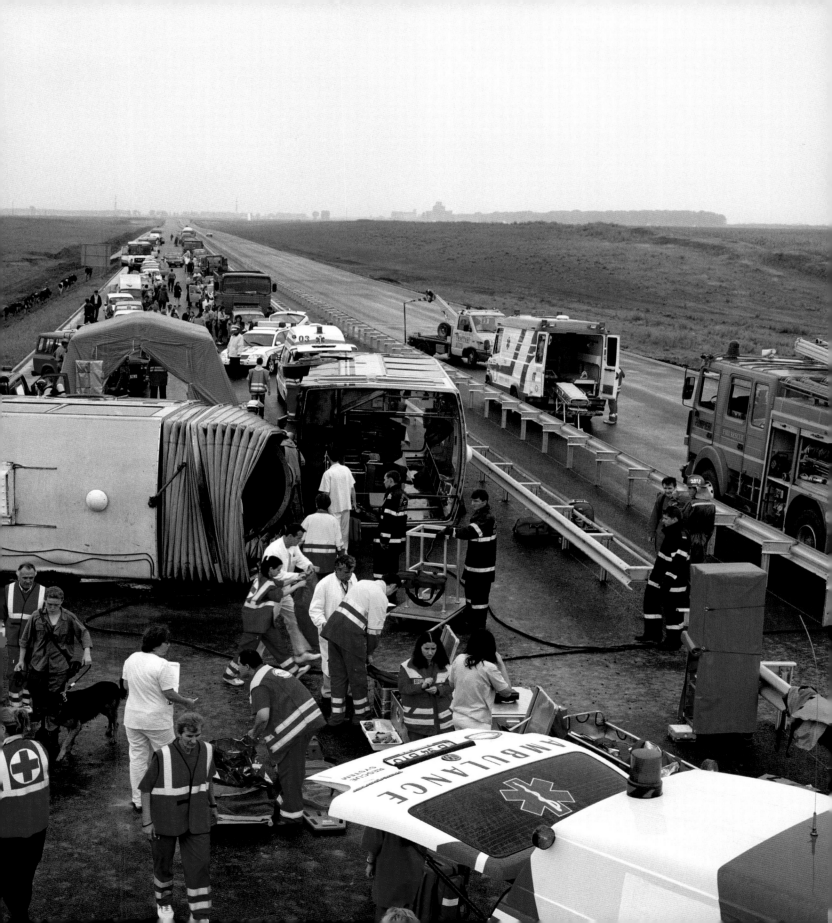

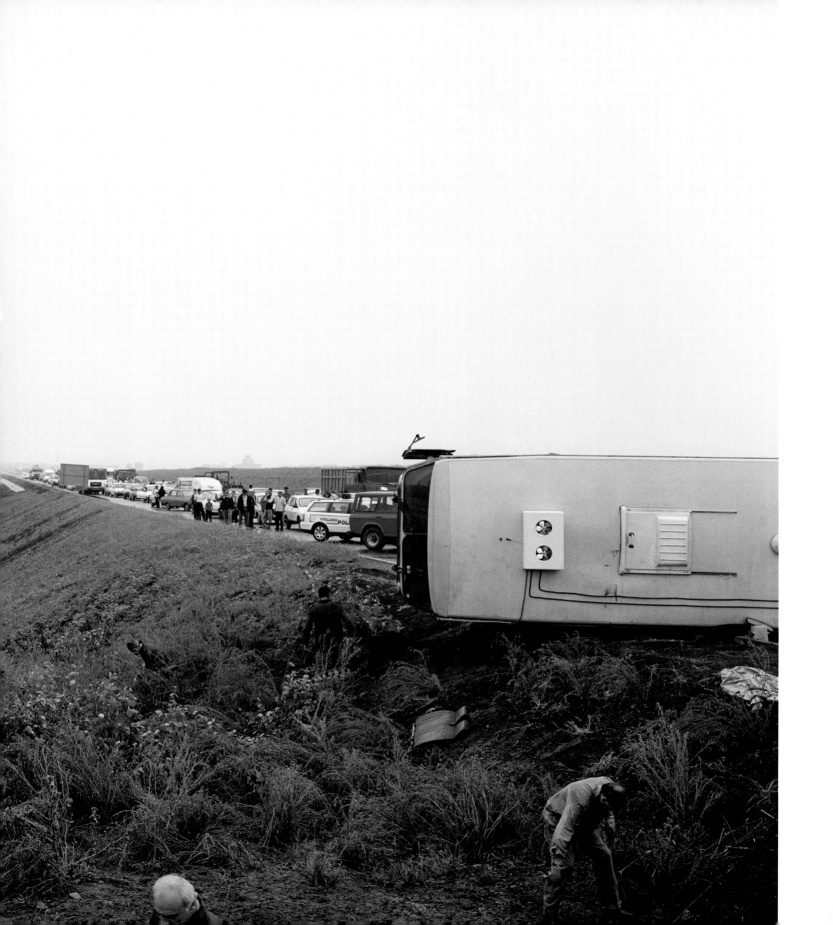

AERNOUT MIK
Born 1962, Groningen, The Netherlands
Lives and works in Amsterdam

Selected One-Person Exhibitions

2005 Argos, Brussels, Belgium
Centre pour l'image contemporain, Geneva, Switzerland

2004 **Aernout Mik: Reversal Room**, Herbert F. Johnson Museum
of Art, Cornell University, Ithaca, NY
Dispersion Room, Haus der Kunst, Munich, Germany
Dispersion Room, Ludwig Museum, Cologne, Germany
Museo de Pasión, Valladolid, Spain
Parallel Corner, The Project, New York, NY

2003 BildMuseet, Umeå Universitet, Umeå, Sweden
The Cleveland Museum of Art, OH
Flock, Magasin 3, Stockholm Konsthall, Sweden
FRAC Champagne-Ardenne, Reims, France
Fundació "la Caixa," Barcelona, Spain
In Two Minds, Stedelijk Museum (in collaboration with
Toneelgroep Amsterdam), Amsterdam, The Netherlands
Les Abattoirs, Toulouse, France
Porin Taidedmuseo, Pori, Finland
The Project, Los Angeles, CA
Pulverous, carlier | gebauer, Berlin, Germany

2002 Contemporary Art Center, Vilnius, Lithuania
Fundació Joan Miró, Barcelona, Spain
Galleria Massimo de Carlo, Milan, Italy
The Living Art Museum, Reykjavik, Iceland
Reversal Room, Stedelijk Museum Bureau Amsterdam,
The Netherlands

2001 Domaine de Kerguéhennec, Bignan, France
Middlemen, carlier | gebauer, Berlin, Germany
Reversal Room, The Powerplant, Toronto, Canada

2000 **3 Crowds**, Institute of Contemporary Arts, London, UK
Primal Gestures, **Minor Roles**, Van Abbemuseum,
Eindhoven, The Netherlands
Simulantengang, Kasseler Kunstverein, Kassel, Germany
Tender Habitat, Jean Paul Slusser Gallery, University of
Michigan, Ann Arbor, MI

1999 **Hanging Around**, Projektraum Museum Ludwig,
Cologne, Germany
Small Disasters, Galerie Fons Welters, Amsterdam,
The Netherlands
Softer Catwalk in Collapsing Rooms, Galerie Gebauer,
Berlin, Germany

1998 Galerie Index, Stockholm, Sweden

1997 Dutch Pavillion (with Willem Oorebeek), **XLVII Venice
Biennale**, Italy

Selected Group Exhibitions

2005 **inSite_05**, inSite: Art Practices in the Public Domain,
San Diego, CA/Tijuana, Mexico
Irreducible: Contemporary Short Form Video,
CCA Wattis Institute for Contemporary Arts,
San Francisco, CA
Multiple Räume: Film, Staatliche Kunsthalle
Baden-Baden, Germany
Trial of Power, Kunstlerhaus Bethanien, Berlin, Germany
Whatever happened to social democracy?,
Rooseum Center for Contemporary Art, Malmö, Sweden

2004 **26th São Paulo Biennial**, Fundação Bienal de
São Paulo, Brazil
Doubtiful, Université de Rennes, France
Fade In, Contemporary Arts Museum, Houston, TX
Firewall, Ausstellungshalle zeitgenössische Kunst,
Münster, Germany
Suburban House Kit, Deitch Projects, New York, NY
The Ten Commandments, Deutsches Hygiene Museum,
Dresden, Germany
That Bodies Speak Has Been Known for a Long Time,
Generali Foundation, Vienna, Austria
This Much Is Certain, Royal College of Art, London, UK
Videodreams, Kunsthaus Graz, Austria
Who If Not We...?: Surfacing: Episode 1, Ludwig Museum
Budapest–Museum of Contemporary Art, Hungary
World Wide Video Festival, Amsterdam, The Netherlands

2003 **Art Focus 4: International Biennial of Contemporary Art**, Museum of the Underground Prisoners, Jerusalem, Israel

© **EUROPE EXISTS**, Macedonian Museum of Contemporary Art, Thessaloniki, Greece

Fast Forward: Media Art/Sammlung Goetz, Zentrum für Kunst und Medientechnologie, Karlsruhe, Germany

In or Out: Contemporary Art from The Netherlands, National Museum of Contemporary Art, Seoul, South Korea

Micropolíticas–Arte y Cotidianidad, Espai d'Art Contemporani de Castelló, Valencia, Spain

OUTLOOK: International Art Exhibition, Athens, Greece

Poetic Justice: 8th **International Istanbul Biennial**, Istanbul Foundation for Culture and Arts, Turkey

Post Nature, Instituto Tomie Ohtake, São Paulo, Brazil

[PRO] CMOTP Festival of Video Art, State Hermitage and State Russian Museum, St. Petersburg, Russia

Die Realität der Bilder–Zeitgenössische Kunst aus den Niederlanden, Staatliches Museum Schwerin, Germany

Die Realität der Bilder–Zeitgenössische Kunst aus den Niederlanden, Stadtgalerie Kiel, Germany

Rituale, Akademie der Künste, Berlin, Germany

Silent Wandering, Postbahnhof am Ostbahnhof, Berlin, Germany

Taktiken des Ego, Stiftung Wilhelm Lehmbruck Museum: Center of International Sculpture, Duisburg, Germany

Turbulence, Centre for Contemporary Art, Kiev, The Ukraine

Turbulence, Museum voor Moderne Kunst, Arnhem, The Netherlands

Zones, Art Gallery of Hamilton, Ontario, Canada

2002 **Ce qui arrive: Unknown Quantity**, Fondation Cartier pour l'art contemporain, Paris, France

Commitment, Fonds voor Beeldende Kunsten, Vormgeving en Bouwkunst, Amsterdam, The Netherlands

Das Museum, die Sammlung, der Direktor und seine Liebschaften, Museum für Moderne Kunst, Frankfurt, Germany

French Collection, Musée d'Art Moderne et Contemporain, Geneva, Switzerland

Geld und Wert, das letzte Tabu, EXPO 02, Biel, Switzerland

Récits, Abbaye Saint-André, Centre d'Art Contemporain de Meymac, France

Stories: Erzahlstrukturen in der zeitgenössischen Kunst, Haus der Kunst, Munich, Germany

Tableaux vivants, Kunsthalle Wien, Vienna, Austria

2001 **Berlin Biennale 2**, Berlin Biennale für zeitgenössische Kunst, Berlin, Germany

Blue Moon, Groningen Museum, Groningen, The Netherlands

Boxer, Kunsthalle Tirol, Austria

Exploding Cinema/Cinema without Walls, Museum Boijmans van Beuningen, Rotterdam, The Netherlands

Future land.com, Museum Abteiberg, Mönchengladbach, Germany

Gravitá Zero/Zero Gravity: Art, Technology, and New Spaces of Identity, Fondazione Adriano Olivetti, Palazzo delle Esposizioni, Rome, Italy

Loop-Alles auf Anfang, Kunsthalle der Hypo-Kulturstiftung, Munich, Germany

Loop-Alles auf Anfang, P.S.1 Contemporary Art Center, New York

Moving Pictures, 5. Internationale Fototriennale Esslingen, Germany

The People's Art / A Arte do Povo, Porto 2001, Central Eléctrica do Freixo, Porto, Portugal

The People's Art / A Arte do Povo, Witte de With Center for Contemporary Art, Rotterdam, The Netherlands

Post-Nature, Dutch Pavilion, **XLIX Venice Biennale**, Italy
Squatters, Fundação de Serralves, Porto, Portugal
WonderWorld, Helmhaus, Zurich, Switzerland
Yokohama 2001, International Triennale of Contemporary Art, Yokohama, Japan

2000 **Desperate Optimists**, Festival ann de Werf, Utrecht, The Netherlands
Still Moving: Contemporary Photography, Film, and Video from the Netherlands, The National Museum of Modern Art, Kyoto, Japan
Territory, Tokyo City Opera Gallery, Japan

1999 **EXTRAetORDINAIRE**, Le Printemps de Cahors, France
Glad ijs/Thin Ice, Stedelijk Museum, Amsterdam, The Netherlands
Holland Kindergarten Japan Bondage, De Vleeshal, Middelburg, The Netherlands
In All the Wrong Places, Ottawa Art Gallery, Canada
Nur Wasser läßt sich leichter schneiden, Hedrichsmühle, Neumühlen-Hamburg, Germany
Panorama 2000, Centraal Museum, Utrecht, The Netherlands
Posttragiko Mik, Palazzo-Delle Papese, Sienna, Italy
Spread, Galerie Index, Stockholm, Sweden
Tales of the Tip: Art on Garbage, Stichting Fundament, Voormalige Vuilstort Bij Bavel, Breda, The Netherlands
A Touch of Evil, Metrónom, Barcelona, Spain

1998 **Do All Oceans Have Walls?**, GAK and Künstler Haus, Bremen, Germany
NL, Van Abbemuseum, Eindhoven, The Netherlands
Zomer, ACHK De Paviljoens, Almere, The Netherlands

1997 **Identité**, Le nouveau Musée, Villeurbanne, France
Personal Absurdities, Galerie Gebauer, Berlin, Germany
Standort Berlin #1: Places to Stay, BüroFriedrich, Berlin, Germany

1996 **Gedraag je**, Stedelijk Museum Bureau Amsterdam, The Netherlands
ID, Van Abbemuseum, Eindhoven, The Netherlands
Making a Place, Snug Harbor Cultural Center, Staten Island, NY
The Scream, Arken Museum of Modern Art, Copenhagen, Denmark
Snowball, Deweer Art Gallery, Otegem, Belgium
Take 2, Centraal Museum, Utrecht, The Netherlands

Bibliography

2004

"Ausstellungen–Videokunst: Alltag als absurder Film–Aernout Mik in Koln und Munchen." **Art**, no. 6: 86.

Breitwieser, Sabine, Hemma Schmutz, and Tanja Windmann. **Das die Körper sprechen, auch dass wissen wir seit langem / That Bodies Speak Has Been Known for a Long Time**. Vienna: Generali Foundation and Verlag der Buchhandlung Walther Konig.

Dercon, Chris, Jim Drobnik, Stephanie Rosenthal, and Ralph Rugoff. **Aernout Mik: Dispersions**. Cologne: Du Mont Literatur und Kunst Verlag.

Kerr, Merrily. "Aernout Mik." **Time Out New York**, May 27-June 3: 77.

Konig, Kasper, Antje Von Graevenitz, and Gerhard Kolberg. **AC: Aernout Mik: Dispersion Room/Reversal Room**. Cologne: Ludwig Museum and Verlag der Buchhandlung Walther Konig.

Levin, Kim. "Aernout Mik." **Village Voice**, May 26-June 1: 80-81.

Seidel, Martin. "Aernout Mik: 'Dispersion Room: Museum Ludwig, Köln.'" **Kunstforum International**, no. 171 (July/August): 345-346.

Van den Boogerd, Dominic. "Choreography of Chaos: Aernout Mik's In Two Minds." **Parkett** 70: 140-144.

2003

Akademie der Künste. **Rituale**. Berlin: Akademie der Künste.

Aliaga, Juan Vicente, Jose Miguel Cortes, and Maria de Corral. **Micropolíticas–Arte y cotidianidad**. Valencia: Espai d´Art Contemporani and Generalitat Galenciana.

Birnbaum, Daniel. "Aernout Mik." **Flash Art** (January/February): 92.

Bonnin, Anne. "État de monde/état de conscience." **Mouvement** (Summer).

Cameron, Dan, and Jorge Wagensberg. **Aernout Mik**. Barcelona: Fundació "la Caixa."

Francblin, Catherine. "Aernout Mik: Retour au point mort." **Art Press France**, no. 290 (May): 40-44.

Groys, Boris. **Taktiken des Ego**. Duisburg, Germany: Stiftung Wilhelm Lehmbruck Museum.

Kielstra, Martijn, and Chegab Yun. **In or Out: Dutch Contemporary Art from The Netherlands**. Seoul: National Museum of Contemporary Art and Yellow Sea Publications.

Knight, Christopher. "Trapped Inside a Zoom Lens." **Los Angeles Times**, April 18, Section E, 26-27.

Landau, Suzanne, and Yigal Zalmona. **Art Focus 4: International Biennial of Contemporary Art**. Jerusalem: Museum of the Underground Prisoners.

Martínez, Rosa, Harald Szeemann, and Antonio Tabucchi. **© EUROPE EXISTS**. Thessaloniki, Greece: Macedonian Museum of Contemporary Art.

Miles, Christopher. "Aernout Mik: The Project." **Artforum International**, no. 9 (May): 176.

Paul, Frédéric. "Aernout Mik: Transes de Vie." **Beaux Arts Magazine France**, no. 225 (February): 64-69.

Turkina, Alicia. **[PRO] CMOTP–Festival of Video Art**. St. Petersburg, Russia: State Hermitage, State Russian Museum, and PRO ARTE Institute.

Von Berswordt-Wallrabe, Kornelia. **Die Realität der Bilder–Zeitgenössische Kunst aus den Niederlanden**. Schwerin, Germany: Staatliches Museum; Kiel Germany: Stadtgalerie.

2002

Birnbaum, Daniel. **Elastic**. Amsterdam: Koninklijke Nederlandse Akademie van Wetenschappen.

Boers, Waling. "Mik's Action Jammin," in **Mediavla: Niederländische Medienkultur**. Berlin: Edition Sutstein.

Borins, Daniel. "Aernout Mik: The Power Plant, Toronto." **Canadian Art**, no. 1 (Spring): 102.

Folie, Sabine. **Tableaux vivants**. Vienna, Austria: Kunsthalle Wien.

Hackett, Sophie. "Aernout Mik: The Power Plant, Toronto." **C: International Contemporary Art**, no. 72 (Winter): 42-43.

58

Heather, Rosemary. "Aernout Mik." **Border Crossings**, no. 1 (February): 77-78.

Kadel, Iris. **Ultime generazioni e new media**. Bologna: Edizioni Cooperativa Libraria Universitaria Editrice Bologna.

Kitamura, Katie. "Aernout Mik." **Contemporary** (April): 113.

Mik, Aernout. "Proposal for Public Plaiv," in **Public Plaiv: Art Contemporauna illa Plaiv**. Zurich: Hochschule für Gestaltung und Kunst.

Monk, Philip. **Aernout Mik: Reversal Room**. Toronto: The Power Plant.

Perra, Daniele. "Aernout Mik." **Tema Celeste**, no. 93 (September/October): 64-67.

Rosenberg, Angela. "Stock-Market." **Flash Art**, no. 226 (October): 86-89.

Rosenthal, Stephanie. **Stories: Erzahlstrukturen in der zeitgenössischen Kunst**. Munich: Haus der Kunst.

Stange, Raimar. "(T)raumatische Ortsbegehungen." **Kunst Bulletin** (March).

Thély, Nicolas. "Aernout Mik: vers une choréographie du reel." **L'Oeil**, no. 539 (September): 34-35.

Virilio, Paul. **Ce qui arrive: Unknown Quantity**. Paris: Fondation Cartier pour l´art contemporain.

Wampler, Liberty. "Feeding into the Loop." **City Beat—Cincinnati** (October): 17-23.

Boers, Waling. "Mik's Action Jamming," in **Loop-Alles auf Anfang**. Munich: Kunsthalle der Hypo-Kulturstiftung

Boubounelle, Laurent. "Aernout Mik: Institute of Contemporary Art." **Art Press**, no. 265 (February): 71-72.

Breitenfellner, Barbara. "Aernout Mik: 3 Crowds." **Springerin** (January).

Ellis, Michael. "Aernout Mik: Institute of Contemporary Art, London." **Art Monthly**, no. 243 (February): 38-40.

Fischer, Jennifer, and Jim Drobnick. "Ambient Communities and Association Complexes: Aernout Mik's Awry Socialities." **Parachute Canada**, no. 101 (January/March): 90-98.

Koplos, Janet. "Laugh Lines: Henk Peeters, Aernout Mik, Willem Sanders and Paul de Reus: Humor in Modern Dutch Art." **Art in America** (May): 95-97.

Mik, Aernout. "Middlemen," in **Yokohama 2001**. Yokohama, Japan: International Triennale of Contemporary Art.

Museum Abteiberg. **Future land.com**. Mönchengladbach, Germany: Museum Abteiberg.

Paul, Frédéric. **Post-Nature: Nine Dutch Artists**. Rotterdam: NAi Publishers.

Rosenberg, Angela. "Aernout Mik." **Flash Art International**, no. 221 (November/December): 87.

Scheutle, Rudolg. **Moving Pictures**. Esslingen, Germany: Hatje Cantz Verlag.

2001

Allen, Jennifer. "Annika Strom/Aernout Mik." **NU: The Nordic Art Review**, no. 6: 67.

Benedetti, Lorenzo. **Gravitá Zero/Zero Gravity: Art, Technology, and New Spaces of Identity**. Rome: Palazzo delle Esposizioni and Fondazione Adriano Olivetti.

Berrebi, Sophie. "Rat Race: Sophie Berrebi on Aernout Mik." **Frieze United Kingdom**, no. 52 (May): 90-91.

Bers, Miriam. "Affect, Not Effect: Berlin Biennale." **Tema Celeste**, no. 86 (Summer): 82-87.

Birnbaum, Daniel, Saskia Bos, Nicolas Bourriaud, and Charles Esche. **Berlin Biennale 2**. Berlin: Berlin Biennale für zeitgenössische Kunst.

2000

Balkenhol, Bernhard. "Systemische Darmverschlingung." **Das Fridericianum Magazin**, no. 4 (Spring).

Balkenhol, Bernhard, Tijs Goldschmidt, Jaap Guldemond, Mark Kremer, Maxine Kopsa, and Aernout Mik. **Primal Gestures, Minor Roles**. Eindhoven, The Netherlands: Art Pub Inc and Van Abbemuseum.

Blomberg, Katja. "Der Schlaf der Vernunft gebiert Komik." **Frankfurter Allgemeine**, February 9: 54.

Blotkamp, Carel. "De werkelijkheid van Mik en Mach." **De Volkskrant**, February 17.

Frangenberg, Frank. "Aernout Mik: 'Primal Gestures, Minor Roles', Stedelijk Van Abbemuseum, Eindhoven." **Kunstforum International**, no. 150 (April/June): 433-434.

Hannula, Mika. "Obsessive Destruction: Pinata of Aernout Mik." **NU: The Nordic Art Review**, no. 17 (May).

Kataoka, Mami. **Territory**. Tokyo: Tokyo City Opera Gallery.

Koch, Corinna, and Christiane Mennicke. **After Work**. Tornitz/ Werkleitz, Germany: Werkleitz Biennale.

Schwarze, Dirk. "Das Ende der Gemütlichkeit." **Das Fridericianum Magazin**, no. 5.

Searle, Adrian. "Like a Pop Festival on the Somme." **The Guardian**, November 28.

Van Nieuwenhuyzen, Martijn, Aernout Mik, and Anne Walsh. **3 Crowds**. London: Institute of Contemporary Art.

Walsh, Anne. **Tender Habitat**. Ann Arbor, Michigan: Jean Paul Slusser Gallery, The University of Michigan.

1999

Beausse, Pascal. **EXTRAetORDINAIRE**. Cahors, France: Actes Sud and Le Printemps de Cahors.

Berg, Ronald. "Laufsteg durch die Katastrophe." **Sonnabend**, October 30.

Denk, Andreas. "Nur Wasser lässt sich leichter schneiden." **Kunstforum International** (May): 341-343.

Dorn, Anja. "Hanging Around." **Frieze**, no. 49 (November/ December).

Keijer, Kees. **Kamerschatten**. 's-Hertogenbosch, The Netherlands: Stichting Kw14.

Lesak, Franziska. "Aernout Mik: Der dreidimensionale Blick." **Eikon Internationale**, no. 30: 21-25.

Van Nieuwenhuyzen, Martijn. "Signs of Life," in **Hanging Around**. Cologne: Projektraum Museum Ludwig.

Visinet, Arnauld. "Deplacements." **Art Press**, no. 244 (March): 84-86.

1998

Andersson, Patrik. "Slow Dance." **Canadian Art** (Summer), no. 2: 72.

Braak, Lexter. "Willem Oorebeek, Aernout Mik: Reinventing Realities." **Flash Art International**, no. 203 (November/ December): 94-95.

Griese, Horst. **Do All Oceans Have Walls?** Bremen, Germany: Gesellschaft für Aktuelle Kunst and Künstler Haus.

Guldemond, Jaap. **Contemporary Art from The Netherlands**. Eindhoven, The Netherlands: Van Abbemuseum.

——————. "Hongkongoria. A Project by Aernout Mik and Marjoleine Boonstra," in **Ironisch/Ironic**. Zurich: Museum für Gegenwartskunst.

Stadler, Eva Maria. **Mise-en-Scène**. Graz, Austria: Kunstverein.

Van Adrichem, Jan. **René Magritte en de hedendaagse kunst**. Ostende, Belgium: PMMK Museum voor Moderne Kunst.

1997

Couke, Jo. **Positions / Positites <40**. Otegem, Belgium: Deweer Art Gallery.

Folkersma, Nina. "Los Zand," in **In de sloot ... uit de sloot**. Amsterdam: Stedelijk Museum.

Lind, Maria. "Stillsam och lyrisk hollandsk surrealism." **Svenska Dagblad**, August 2.

Van Winkel, Camiel. "Excursions with Tennis Balls, Shiny Knees, and Green Slime," in **Aernout Mik/Willem Oorebeek**. Amsterdam: Stedelijk Museum and Mondriaan Foundation.

1996

Centraal Museum. **Take 2**. Utrecht: Centraal Museum.

Chodzko, Adam, Lynne Cooke, Jan Debbaut, Jean Fisher, Jaap Guldemond, Mark Kremer, Stephanie Moisdon, Gregor Muir, Michelle Nicol, Oliver Sacks, and Mats Stjernstedt. **ID**. Eindhoven, The Netherlands: Van Abbemuseum.

Kersting, Rita. "Aernout Mik. Langer oder liegender Affe Servatiiplatz Munster," in **Abendland**. Munich: Städtische Ausstellungshalle am Hawerkamp.

——————. **Snowball**. Otegem, Belgium: Deweer Art Gallery.

Levin, Kim, and Holger Reenberg. **The Scream**. Copenhagen: Arken Museum of Modern Art.

1995

Coelewij, Leontine, and Martijn Van Nieuwenhuyzen. **Wild Walls**. Amsterdam: Stedelijk Museum.

Couke, Jo. **Aernout Mik**. Otegem, Belgium: Deweer Art Gallery.

De Vleeshal. **Mommy I Am Sorry**. Middelburg, The Netherlands: De Vleeshal.

Foundation Clair Obscur. **La valise du célibataire/De Koffer vande celibatair**. Maastricht, The Netherlands: Foundation Clair Obscur.

Kunstverein Hannover. **Wie die Räume gefüllt werden müssen**. Hannover: Kunstverein, Hannover.

"The Life of a Repo Man Is Always Intense: Richard Hoeck, Aernout Mik, Joëlle Tuerlinckx." **Archis**, no. 6 (June): 70-80.

1994

"Aernout Mik," in **L'Ecole d'Eloe**. **Le vent du nord X**. Paris: Institut Néerlandais.

Beurs van Berlage. **Ik + de Ander**. Amsterdam: Beurs van Berlage.

Kremer, Mark, and Camiel Van Winkel. "Interview with Aernout Mik." **Archis**, no. 1 (January): 68-74.

1993

Bosma, Marja. **Peiling**. Utrecht: Centraal Museum.

Institute of Contemporary Art, Amsterdam. **Recto/Verso Signalen III**. Amsterdam: Institute of Contemporary Art.

Van Winkel, Camiel. "Aernout Mik, Adam Kalkin: The Philosophy of Furniture." **Archis**, no. 3 (March): 12-13.

1992

Couke, Jo. **Für Nichts und Wieder Nichts / Stuffed, Weak, and Filthy**. Otegem, Belgium: Deweer Art Gallery.

Stedelijk Museum. **Amsterdam koop kunst**. **Gemeentelijke Kunstaankopen**. Amsterdam: Stedelijk Museum.

1991

Kalkin, Adam. **On Aernout Mik**. Eindhoven, The Netherlands: Van Abbemuseum.

1989

Feoj, Emilie. **Mik-Leijenaar-Strik**. 's-Hertogenbosch, The Netherlands: Museum't Krithuis.

1988

Poot, Jurrie. **Een Grote Activiteit / Great Activity**. Amsterdam: Stedelijk Museum.